SUNSETS & SEASONS

A Journey From The Wilderness

CONNIE KESSLER

WestBow Press books may be ordered through booksellers or by contacting:

WestBow Press
A Division of Thomas Nelson & Zondervan
1663 Liberty Drive
Bloomington, IN 47403
www.westbowpress.com
844-714-3454

ISBN: 978-1-6642-3893-0 (sc)
ISBN: 978-1-6642-3892-3 (e)

Library of Congress Control Number: 2021913242

Print information available on the last page.

WestBow Press rev. date: 08/02/2021

The "Accidental Poet".

This composition was borne out of life.
Every. Day. Life.
We all experience sunsets and seasons
in our own lives.

Days of hardship and sorrow -
Days of extreme happiness and joy.
And some days just numb
and going through the motions.

So, wherever you find yourself -
find something to bring a smile.
Train yourself to look for the good.
Someone once said, "Let your pain become your inspiration".
I thought that was some pretty good advice.

For years I was bound up in survival mode-
trying to do it all- prove myself- be worthy.
In doing so, I lost sight of the
important "little" things.

Thus, the title, Sunsets and Seasons.
Because every day there is beauty around us,
and every day we can choose to see it.

Ecclesiastes 3: 1 KJV
1 To every thing there is a season,
and a time to every purpose under the heaven:

Acknowledgments

There are many people God has placed in my life. Some for a season, others were my sunrises and sunsets. Each was meant to mold and shape, polish and refine during this journey. However, the season that taught me the most about life, my own motives, and the condition of my heart was parenting my own child. God knew what He was doing but oft times I did not. It is his greatest illustration of His unconditional love that he has for all of us. My Jessi, my heart, as much as I love you, He loves you more.

- To my true friends who have loyally and steadfastly stood by me, and just believed in me, during these seasons, there aren't enough words to thank each of you.

Special thanks to:

My Heavenly Father, who makes ALL things possible in a heart that is willing.

Harry Fuller, for many years of pouring wisdom and understanding in my awkward seasons and being the first to proof my manuscript.

Rebecca Perry, for her friendship and allowing me to use her beautiful sketches.

Kelly Fox, for her friendship and allowing me to use her art in pictures of capturing "Pops".

My dear Cynthia Gover, for her friendship and being the second to candidly proof my manuscript.

Camera One, for making the Author pic look good. Thanks Sam.

Dedication

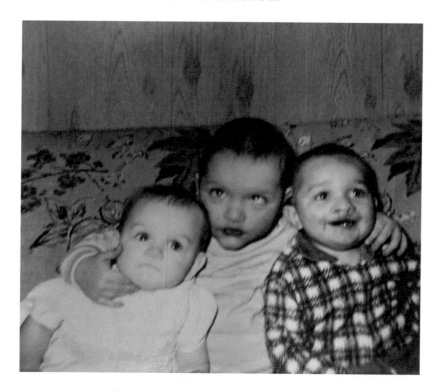

This work is dedicated to these three faces.
You know the story.
You know the places.
You are loved.

Contents

Vanity

I see things you cannot see
blinded by pride and station.
guided only by self
and fulfilment of timeless immortality.

If only in retrospect to see
How much wisdom could be gleaned
From the guiding hand of The Almighty
And a brother in need to be.

Alas not meant to be
The handwriting on the wall to see
In vain the toil
the strive to gain
To see it slowly drift away
into the night nevermore.

Psalm 94:11
The Lord knoweth the thoughts of man;
that they are vanity.

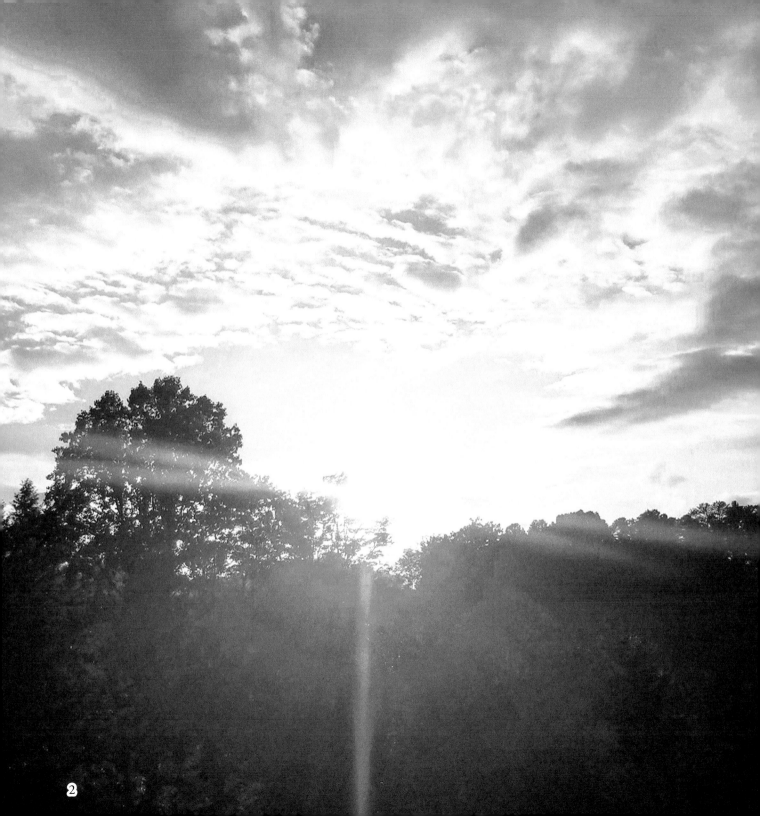

We Can't See The Forest For The Trees

(A Reflection on Life)

Each day we toil along our way
Never seeing the simple,
the good, in each day.
The beauty of the breaking dawn.
The glorious splendor of the sunset.

Yet we toil, we labor
All for selfish gain and
not for good of fellow man.

All the while we miss
The wonder, the thrill,
The sheer abandonment of anything evil.
Of children's laughter
Of their innocence and wonder
Of all things new in their sight.

Of majestic mountains to oceans blue
Behold nature's beauty abounds.
From birth until death
Such beauty the eyes shall behold.

What will we have gained?
While life is passing by.
All the struggle all the toil.
Will soon just fade away.

Yet the beauty and the splendor
The majesty and the wonder
Of all earth's treasures
Will gently fade away to nevermore
as undiscovered rare gems
In the hand of the Creator.

Psalm 90:10
As for the days of our life, they contain 70
years, or if due to strength, eighty years.
Yet their pride is but labor and sorrow for
soon it is gone and we fly away. NASB

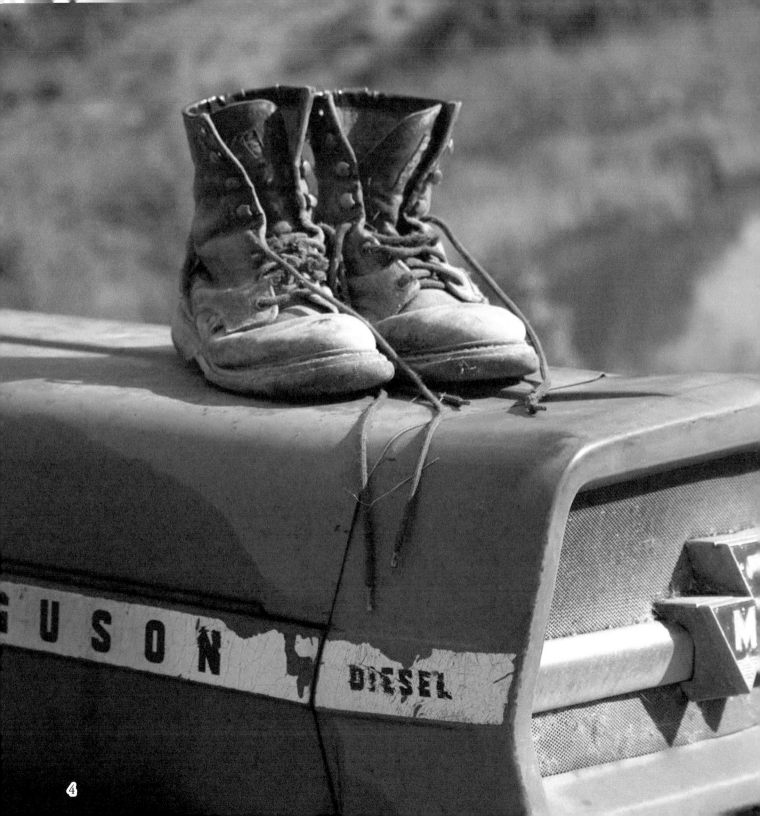

"Pops"
7-11-37 -10-18-18

My dad was not a fancy man
mostly jeans and flannel-
but he wore his "Sunday" suit to church
boldly, proudly on those "special" occasions.
all proper and just -
as surely Grandma would have it.

A hardworking man
built to last
all the effects of
nature, land and
his love of farming.

Not one to mince words
or be "politically" correct
but rather he spoke
with conviction and earnest values.

His children were made for workin'
each season in and out
'til all the ends were met
and the bases covered.

No rest 'til secure
to do again
in season and out of season
that was the man he was.

He knew his Bible
he knew his choice words
those most especially used
with a kid or cow out of line.

His hands worked long and hard
at the task at hand -
'til the silence at last would still.

Heaven issued the call
His turn had come.
Come Home my child
Your work is done.

Psalm 104:23
Man goeth forth unto his work and to his labor until the evening.

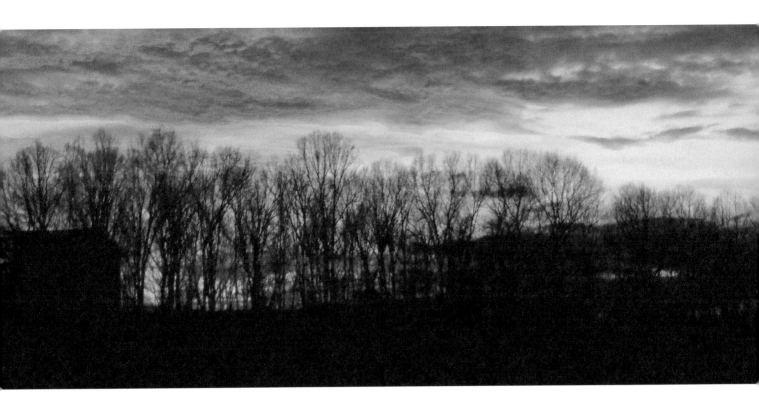

MTHS - Class of 1979

How long ago it was
we walked the halls
dreaming of our future
so bright and fair.

Would we be doctors, lawyers, mothers, fathers?
Would we serve our country?
Bravely, fiercely defending her Honor.

All the while
the friendships to savor
"bffs" forever we would be.

Alas, we have lived our lives
quietly, steadily
fulfilling our destiny
as was meant to be.

But still, we cherish
the memories so dear
of the times we had
at our alma mater
MTHS.

Jeremiah 29:1
For I know the plans I have for you, declares the Lord,
plans to prosper you and not to harm you, plans
to give you a hope and a future. NIV

6

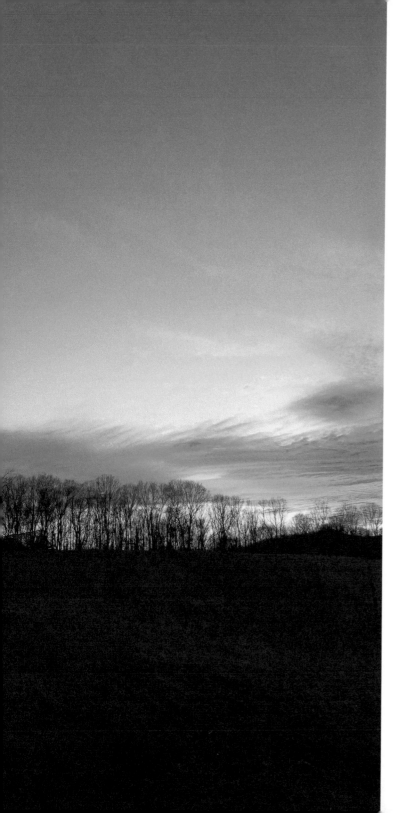

Friends

It has been said
friends are our chosen family.
It has also been said
friends are the spice of life.

Friends can be for a season
or only for a reason.
Friends can be for a lifetime
the rare and purest form.

But I say God gives us friends
to fill in the gaps
in those hidden places
in our lives.
Some are for a shoulder
some for us to shoulder.
Some to sharpen
some to soften.

All in all, God's hidden treasure
Can be the gold we find
in friends to weather life's storms.

Proverbs 18: 24
A man of many companions may come to ruin,
but there is a friend who sticks closer than a brother. ESV

Brother

He knew he had a place
he never had to beg
all the while
the rest of us
begged
for crumbs from the table.

It was always said
time and time again
he has a place
it's his you said.

All the while
silently...
slowly...
wishfully thinking....

One day we will have a place
One day we will be loved
One day the blessing we will receive.

However, that time
will never come
never will those words be spoken
never the blessing to receive.

All is silent
cold and stiff
The time has come
The door is shut
always and forevermore.

Psalm 27:10
Though my father and mother forsake me,
the Lord will receive me. NIV

Taken for Granted

People scurrying along
In the hustle and bustle of life
Failing to see or appreciate
The simple beauty and mystery of life.

The laughter of a child
The smell of crisp mountain air
The endless ocean roars
The grand beauty that nature possesses.

Why must we always labor and toil
For gain that in the end must spoil.
For all is naught and a legacy in vain
if no one's life is touched
or one's soul is secure
in the Love of the Almighty
the Creator and the Master.

What beauty we can possess
When with eyes we can see
With the help of the Master
The great Artist
of such masterpieces which
Only He can reveal.

Micah 6:8
He has shown you, O man, what is good ; and
what does the Lord require of you,
but to do justly, to love mercy and to walk
humbly with your God. NKJV

One Day

One day I will do this or that
One day I will go here or there
One day I will fix this or that
One day I will buy this or that
That is what I always say.

The funny thing is
One day never seems to come
Never time to do
Never time to go
Never time to fix or
Never time to buy that dream.

Waiting for one day
will only make you sad
Waiting for one day
may even make you mad.

Somehow, we forget to live
waiting on some day to arrive.

Matthew 6: 34
Take therefore no thought for the morrow;
for the morrow shall take thought for the things of itself.

Never Good Enough

Rise and shine they say,
The early bird gets the worm they say,
Work hard and you will succeed they say.

What is the price of success -?
the hidden meaning of status and position?
Some people work 2 jobs - are they a success?
The McDonald's worker vs. the member of Congress.
Equal opportunity for all
seems to be hidden from view.

But underneath it all,
the hidden agenda of stature,
the drive of status and riches.

All in all, you're told
spoken or unspoken

You're never good enough.
Too fat, too skinny,
Too short, too tall.
Work too hard,
Don't work hard enough.
You can never measure up.

Scurrying like ants
Grinding a path
Never satisfied with self
or other's opinions of stature.

But what if we pause
What if we breathe
Cherish the small,
seemingly insignificant,
word or deed
that comes our way
each and every day
'til we all change
our little corner of the world.

Ecclesiastes 7: 5
It is better to hear the rebuke of the wise,
than for a man to hear the song of fools.

Some Days

Some days it's so hard to see
the beauty, the promise
the blessings of the day.

Some days are just
a continual struggle and
with each decision
a battle within.

Remind yourself
Train yourself
Look for the small beauty,
the wonder of life
which is truly miraculous.

The birth of a child,
the emerging of a butterfly
with beauty beyond imagination.

Lift up our eyes
our souls will soar
and thus
our 'somedays" will pass!!

Ecclesiastes 7:3
Sorrow is better than laughter;
for by the sadness of the countenance the heart is made better.

United

We all bring something to the table
Whether it be the strength of youth,
the wisdom of years,
the tools of the trade, or
the vitality and eagerness to get the job done.

What good would be
if we all joined in
a common bond,
a unity of wills,
what accomplishments could be had.

Thus, the pride of life,
the arrogance of stature,
the knowledge and education
which puffs up the ego
and thus
war and competition are our foe.

We must endeavor to see
the error of our ways
to leave a world
of wonder and excitement
for the future generations.

Colossians 3:13
Forbearing one another, and forgiving one another,
if any man have a quarrel against any: even as Christ forgave you, so also do ye.

Silently

Silently all the tears
she cried over the years,
Silently she mourned
over the losses,
of friends,
friendship forsaken,
love that was lost.

Silently, slowly
arose a new vision
A purpose and a plan.

Let us learn and listen
unfold a new plan.

Let us guide and direct
the losses for good.

Let us forge ahead
before time and eternity
looms before us
and time shall be no more.

Joel 2: 21
Fear not, O land, be glad and rejoice for
the Lord will do great things.

I Wish

I wish you enjoyed spending time together.

I wish you would say let's enjoy the day together.

I wish it were not so stiff and awkward
just to be in the presence of the other.

How did it happen
was it always so?

Did I cause a rift or
speak in strife?

Each day to unfold
a new battle of wills
never understanding the other's plight.

How do we bestow honor
if it's not wanted or accepted?

How do we show love
if it's never received?

It seems set in stone
carve it upon the marble
the plight of the misunderstood
and the ones to blame.

Never seeing or hearing
all life has to offer
to laugh, to share
the joy of the day.

I wish it could be
I wish it were so
Yet all I can do
is wish it would be.

Amos 3: 3
Can two walk together except they be agreed?

17

I Miss

I miss the laughter so rich and sweet
I miss the smiles and also the tears
I miss the times that were had.

All the heart to heart
kitchen talks
over a hot meal of
double carbs and sweet treats.

I miss the youth
the energy and bravery
to take the risks
with joy and abandonment-
the surety in knowing we were
on course with life.

I look in the mirror
and what do I see
a stranger with eyes full of pain;
Some regrets for paths taken
some regrets for paths not taken.

With age comes wisdom
but shortcomings anew
Afraid and frail
can't take the risk.

A glance afar
a glance amiss
now adrift thus far
left pondering anew.

What fate lies ahead
on that distant shore
awaits our eternity
forever we shall go.

2 Corinthians 12:9a
And He said to me, My grace is sufficient for thee,
for my strength is made perfect in weakness.

'A Year'

It's been a year
since you've been gone
no chance to say goodbye
no farewell to ground and sky.

Adjustments have been made
goodbyes
to the ways,
the seasons,
the habits of old.

Mere mortality in an immortal soul
Gone back home from whence it came
now knowing - no longer longing
for shelter from the
storms of life.
In the aftermath we ponder
sometimes longing of
what used to be.

But all in all, knowing
the soul is at rest
all peaceful and secure.
So long Pops
You're home at last.

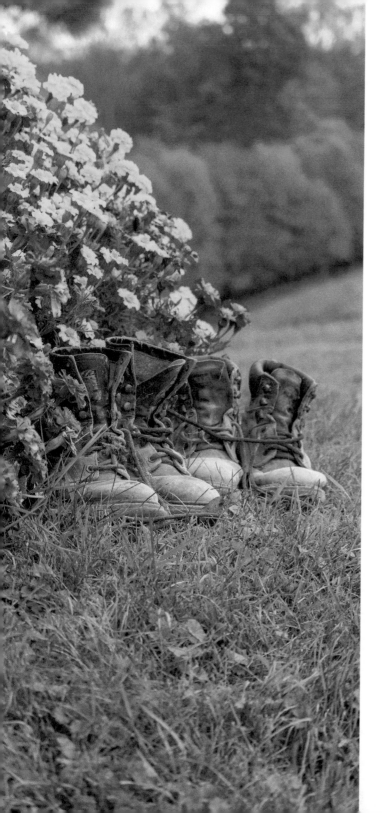

I Grieve

I grieve not as I see others grieve
But still I grieve.

There is still a sense of loss
an emptiness in one's soul.
The awakening to compassion
empathy for the fellow griever.

One must look inside
wonder as to the meaning;
Some lose their soul mate
Still others their lifelong
friend and mentor.

No grieve can compare
to the loss of a child -
not the natural order.

For some it's their very
ground and foundation;
Mother & Father
their base- their security.

One must ponder
Perhaps reason
Allow the season
Sometimes to shake us
to our very core.

I grieve not as I see others grieve;
But still I grieve.

Revelation 21:4
And God shall wipe away all tears from their eyes,
and there shall be no more death, neither sorrow nor crying,
neither shall there be any more pain for the
former things are passed away.

I Don't Count

How many times in life
have the voices around you said -
I Don't Count.

Maybe in word
Maybe in deed
But the message was clear
I Don't Count.

It can start early in life
that voice that resonates
over and over
I Don't Count.

How does one fight
How does one achieve
a proper balance
a healthy sense of worth;

Not just a bloated ego
full of pride and self satisfaction
but to be conscious of our fellow man's suffering.
Lending aid - offering compassion
yet tempering our own selfish ambitions?

All in all we find
Looking to the Almighty-
the creator of all things
our perspective will clear.

We begin to emerge,
We matter to Him.
His way and His purpose
to fulfill our chosen destiny
all through Him.

John 14: 1
Let not your heart be troubled,
ye believe in God, believe also in me.

22

Every Day

Every day is a gift
All things to be seen and savored
Every day we should thank the Creator
for each and every thing that is in our path.

We are blinded by fear,
our ambitions, status or position,
we get so caught up in our 'me' mentality,
it can be in our own sorrow or in
our pursuit of fame or riches.

We miss the beauty around us,
to the very air we breathe
as well as
our sight, scents and abilities we are given.

We were created for His glory and honor
but man claims these as his very own.
Walking in our own status and position,
education or power
not realizing
we are mere mortals of clay
and thus we shall return to clay forevermore.

Joshua 1:9
Have I not commanded thee?
Be strong and of good courage;
be not afraid, neither be dismayed,
for the Lord thy God is with thee, wherever you go.

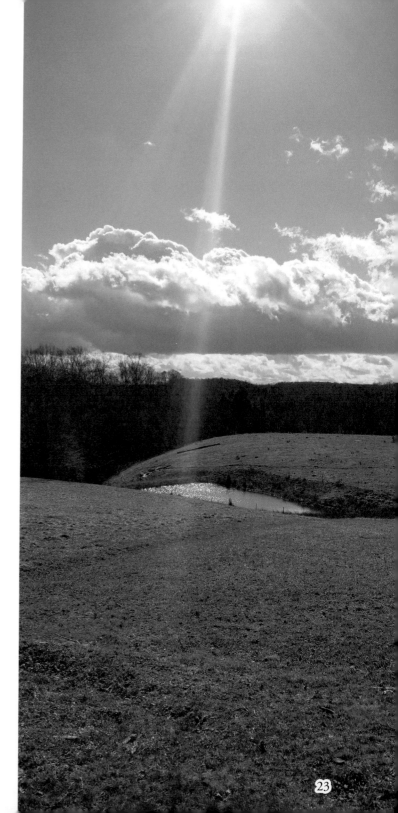

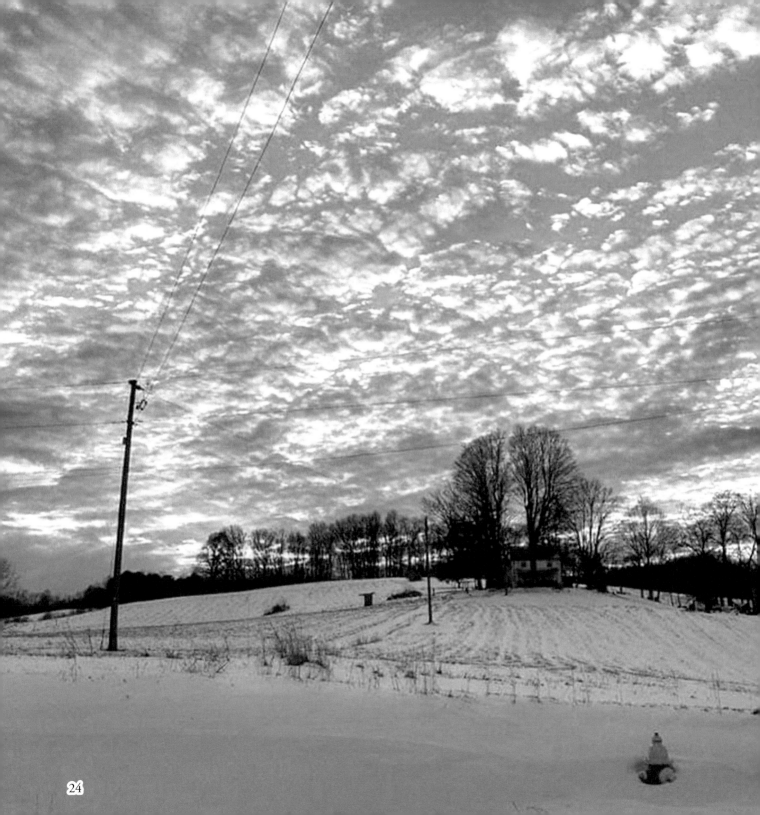

The Gift

We're all given a gift -
the gift of life.
Whether we choose to use it
or lose it
the choice is up to us.

Do we accept this gift
or
Do we reject this gift.

Do we treat it carelessly
or just casually as in jest.
Do we honor it -savor it
as a cherished prize,
or do we toss it aside
meaningless with no worth.

Will we accept our gift
will we unwrap it ever so carefully,
receive the wonder
and excitement it brings?

Will we just kick it to the curb
just stumbling along
accepting whatever comes our way
with casual abandonment.

But just maybe we'll receive
this most gracious gift,
Maybe we'll receive
its joys and sorrows
in season and out of season.

All the while discovering
His plan and His purpose,
to a life lived to its full potential
soaking in the wonder and excitement
the good and the bad
til our time is done
the sun will set
at least our joy will be complete
our purpose will be accomplished
for His glory and honor.
The Greatest Gift.

Genesis 2: 7
And the Lord God formed man of the dust of the ground,
and breathed in his nostrils the breath of
Life; and man became a living soul.

'Freedom'

We say we are free
but are we free indeed.

Land of the Free
Home of the Brave
is the American motto.

Are we at no other time in history-
Are we more timid, fearful, anxious,
weighed down by worry and dread?

Our self made prison with bars,
we carry a heavy ball and chain
each and every each day;
waiting, wondering,
even expecting
the next disaster to fall.

Our children have caught the 'fever'
more and more each day -
The fear, the hopelessness, the dread.

There is loss of hope,
there is despair,
one by one,
which affects us all.

This ought not be
This ought not so.

Fear and doubts assail us
like fiery darts they pierce.

What happened to our
Land of the Brave
Home of the Free?

Let's take back our heritage
one by one.

Let's bravely face those fears
Let's bravely battle those doubts.

Guided by the Hand of the Almighty
as our forefathers surely did.

Til we leave our legacy
of
Land of the Free
Home of the Brave.

Psalm 118: 5
Out of my distress I called on the Lord;
the Lord answered me and set me free. AMPB

'Chosen'

Being chosen is a right denied to many
or so it would appear to be.
Often misjudged
overlooked or
just plain invisible to the world.

Many search for love
often missing the mark
overlooking peace, joy and happiness
that they already have.

Many work 'til they drop
being the classic overachiever
striving for that elusive perfection.
All in all based upon
Man's perception
man's philosophies,
man's limited knowledge and intellect.

Some become the classic people pleaser
always making sure all is taken care of
always being the last to be thought of;
all of which is driven by a desire
to be accepted, loved and chosen.

But what if we grasp
dare to accept
what we already have?

We are chosen and created
by the Hands of the Almighty;
Loved and accepted
and dare we say
CHOSEN
by the Hand of God Himself?

Nothing to earn
Nothing to please
Just to freely accept
the tremendous gift
of His creation,
His love,
His guidance.

In a world full of sorrow and pain
at the hands of mankind's devices and schemes,
acting on lusts and passions,
who is striving for
knowledge and perfection
that only belongs
to the Creator
the Master of the Universe.

Deuteronomy 14:2
For you are a people holy to the Lord your God,
and the Lord has chosen you to be a people
for his treasured possession,
out of all the peoples who are on the face of the earth. ESV

"Fool's Gold"

In search of gold,
In search of riches.
We go along seeking- searching for
the elusive "pot'o gold".

We dig, we build
Our castles in the sand,
never seeing the futility
of what we seek.

Perhaps the "gold" we pursue
the "gold" we seek,
has always been
right before us
all along.

While we search in vain
alas to discover
all it really was
indeed only "fool's gold".

Proverbs 28:26
Whoever trusts in his own mind is a fool,
but he who walks in wisdom shall be delivered. ESV

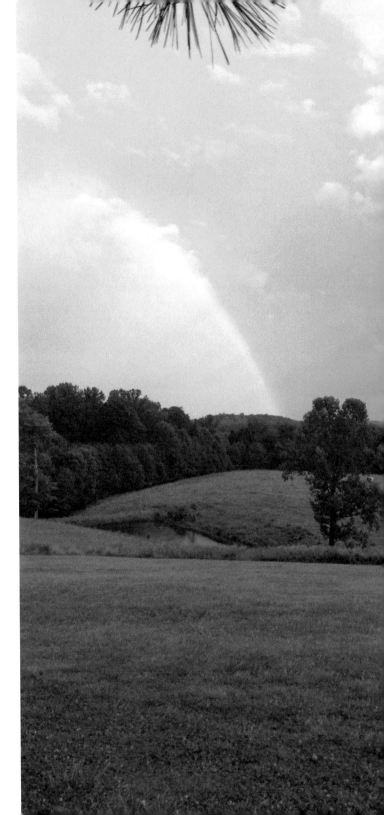

No Vision

We wander along
tossed to and fro
no anchor no hold
no shelter from life's storms.

We race, we stumble,
we climb, we falter.
We chase the dreams,
the ambitions, the ways,
only to see it's not enough,
its pressure is crushing.

No stability to all
the plans and the reasons.
Living by our passions
seeking our own preferences
instead of our purpose,
that reason for being.

The Creator created the creature
all for His plan and purpose.
To be worked out according
to His ways and His design.

Yielding our own selfishness
and learning to give
leaves a lasting legacy
to all who cross our path.

Proverbs 16:9
The heart of man plans his way,
but the Lord establishes his steps. ESV

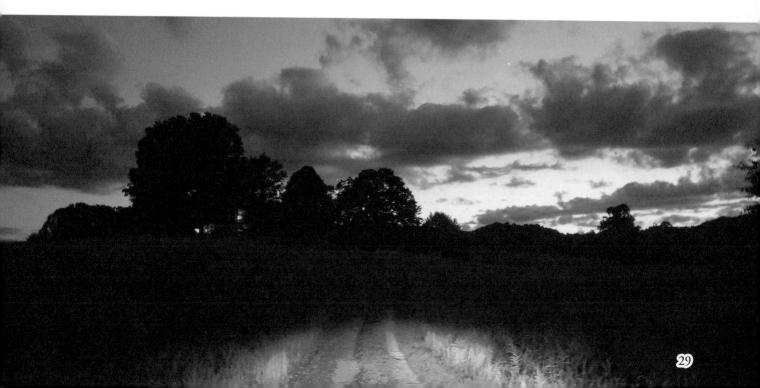

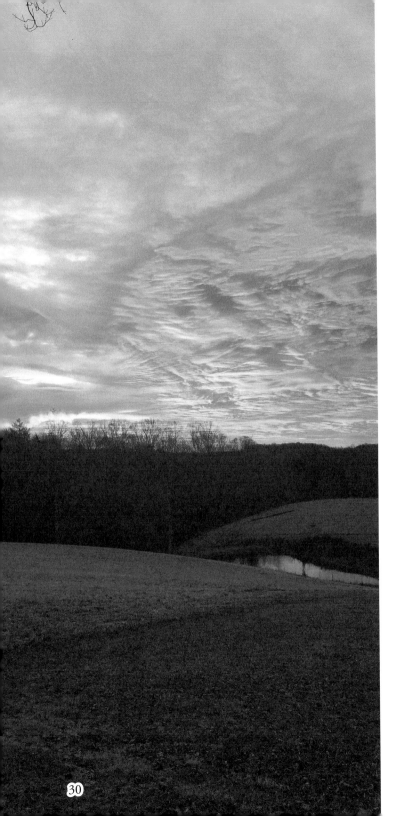

Reflection

Enjoy each day they say,
Savor the moment they say
as we go along life's way.

What do we miss
What do we gain
in life's toil
each and every day.

We're building
We're achieving
We're running the race,
But for what prize
are we running,
Toward what end are we striving?

We think, we ponder
We scheme, we devise,
all the while missing the mark.

Disappointment sets in,
we miss the joy
in our journey set before us
meant to savor those moments;
'til upon reflection we see
we 'get it'.

We talk of old memories,
people who have crossed our path,
We remember no more,
the ambition, the drive.
Just sweet memories of days gone by.

Philippians 4:8
Finally, brothers, whatever is true, whatever is honorable,
whatever is just, whatever is pure,
whatever is lovely, whatever is commendable,
If there is any excellence,
if there is anything worthy of praise,
think about these things. ESV

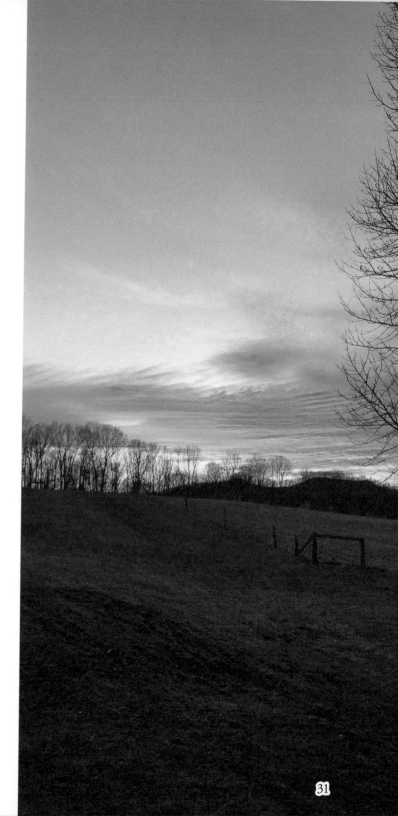

Legacy

We all leave a legacy
Memories,
good or bad
hatred or bitterness
love and kindness shown to others.

It can be bittersweet
or just plain bitter.
Patterns of behavior
set in stone,
fixed
unmovable
like a cornerstone.

Demons that can't be conquered -
thus disallowing love and healing to take place or
allowing relationships to grow and flourish
to nurture the mind and soul;
or to allow the grace and mercy
of the Almighty
to unlock the heart of stone.

Instead it becomes an unquenchable fire
a furnace that is stoked
until the flames
consume body and soul.

*Proverbs 13:22 A good man leaves an inheritance
(legacy) to his children's children. ESV*

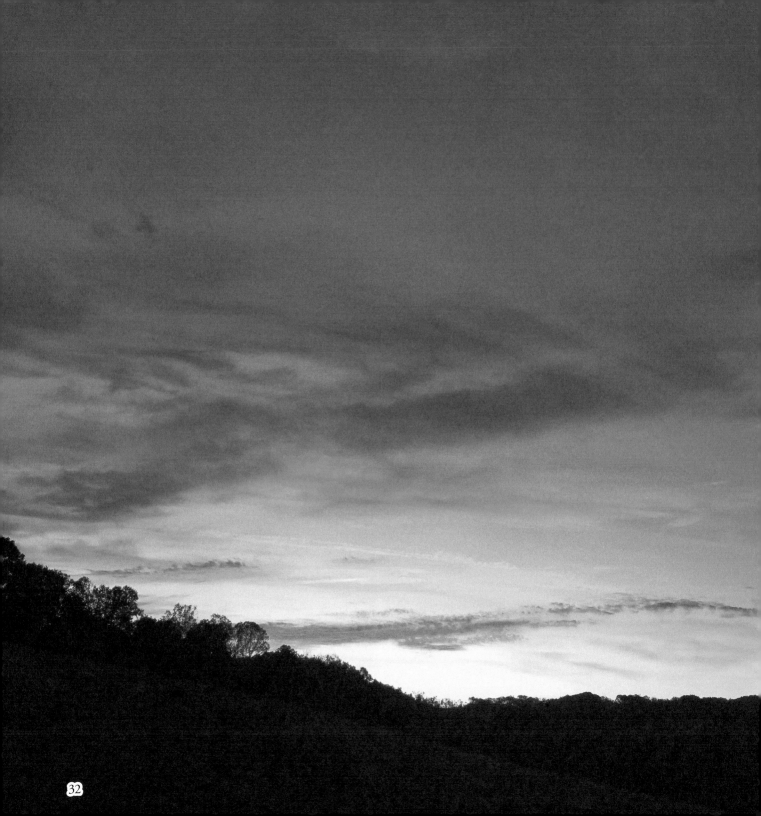

Routine

The very things we run from
and seemingly are stifled by
are the very things
that ground us and define us.
The boring, the mundane
or so it appears to be.

Could it be shaping us, molding us
for our destiny, our purpose
in who we were made to be.

As a child grows and learns
so we should always be
in attendance
in the school of life.
Upon such lessons we stand
lest we fall.

We shall teach them to others
along the way.
Facing life's challenges
with boldness and confidence
Knowing we were formed and shaped
by the Hand of the Almighty
for purpose and for reason.

Psalm 139:13 For you created my inmost being;
you knit me together in my Mother's womb. NIV

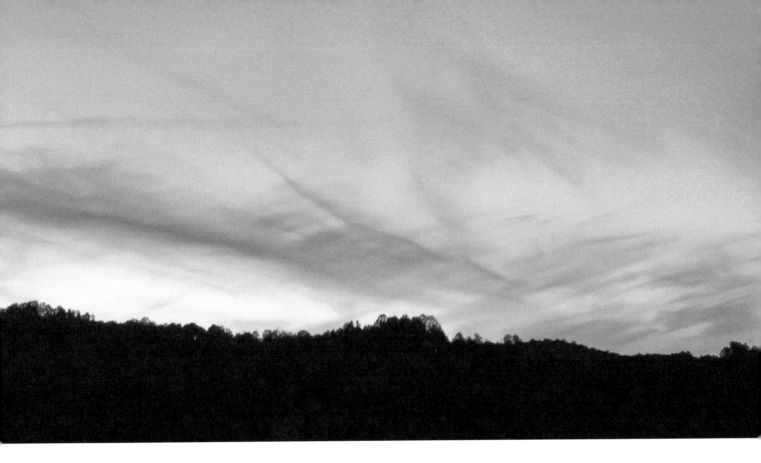

"Today I Had A Bad Day"

Today was a bad day
battling those voices within
Whose voice was clamoring for attention
causing the tidal wave of doubt and fear?

But was it really a bad day or
was it not another gift freely given
not to be driven by fear and doubt
but to savor the blessing,
the moments that time stood still,
the golden rays of sunshine,
the balmy skies above,
to remind one and all
of the gift of life.

Check again-
readjust that tunnel vision;
the Almighty hasn't stopped
loving His creation
even though
Today I had a bad day.
Therefore, I shall be grateful for the gift,
I shall savor the gift
and alas tomorrow
shall be a better day.

Psalm 3:4
I cried unto the Lord with my voice, and
he heard me out of His Holy hill.

Rhythm

Some find their rhythm early in life
still others seek and search their entire life
and then there are others who
effortlessly sing.

Will it be an anthem so bold and crisp?
or a soft melody to hum;
Maybe a choir or a band with beat.

However, it may be
or how it shall be so,
One must find their rhythm
to carry on each day.

Along the paths of life,
some good, some bad,
or some just somewhere in between,
the soul knows what the mind suppresses.

Let your soul breathe,
Let your soul soar,
May you ever find that glorious rhythm.

Proverbs 17:22
A joyful heart is good medicine, but a
crushed spirit dries up the bones. ESV

It's OK To Not Be OK

It's ok to not be ok,
Let's just don't allow ourselves
to stay captive to our thoughts and feelings.
Feelings deceive and are ever changing;
they blow to and fro like the wind.
Thought patterns,
Old habits,
Which seem to be set in stone.

Yet still we can rise,
We can dust off the shadows of yesteryear;
Own it -
Claim it-
Put it in its rightful place,
Moving forward to a better reality-
A clearer view;
A refining process which takes place
in the school of life.

They say patience is a virtue
but humility is long lost.
To walk humbly with our God
and our fellow man,
listening-
observing-
sifting the matters in hand.

So let's resolve to capture the past
and savor the moments
for in those moments
He whispers Peace, Be Still.

So let's allow the Maker to purpose
our days to completion.

Isaiah 43:18-19
Remember not the former things, nor consider the things of old.
Behold, I am doing a new thing, now it springs forth,
do you not perceive it?
I will make a way in the wilderness and rivers in the desert. ESV

Hidden Treasure

Out of once was can be
Out of the ashes can rise
Yesteryear can merely be
an instrument of song
to tune - to refine
One's sense of purpose,
One's mission in life.

To enjoy - to soak
Life's lessons had
the good or the bad
as deemed by the Maker;
to polish-to grind
to savor - to shine
All in the mighty hands
of the Creator
is the Creature.

Sculpted with exactness
precise timing and method,
like a hidden treasure
to be discovered
to be developed
all to be delivered to completion.

Isaiah 61:7
For your shame, ye shall have double,
and for confusion they shall rejoice in their portion;
therefore, in their land they shall possess the double;
everlasting joy shall be unto them.

Complete

We long for this -we long for that
if only this -if only that
the restlessness of spirit
the longing of soul.

Why must we long
Why must we strive
all for vanity and a lost cause;
The fountain of youth must be had
the riches must be gained.
All in all, the age will come
and the riches will spoil.

Be at rest my soul
Be at peace my spirit
'til all will be made complete
the circle will be made whole.

Until that time we must endeavor
to work for a greater cause
to give, to love, to honor
all the blessings of life.
The very air we breathe
the food we eat
the comings and goings of life.

Let's honor the Creator
who made one and all
with love and purpose
to complete His design.

Romans 1:25
"Who changed the truth of God into a lie,
and worshiped and served the creature more than the Creator,
who is blessed forever. Amen"

Free

Why must I wear
my insecurity
Like a garment
tightly woven
to cover me.
Why must I build
a case against myself
before I ever start.

It weighs me down
It spins and swirls
Ever reminding me
Don't show too much heart
Don't let them see.
The real me
The true me
Longing to be free.

To dance to twirl
To laugh to cry.
All to breathe.
To release the chains
No more to be bound
by invisible threads or
unrealistic expectations
of others who are not free
who bought the lies
Told and untold
Forever bound up in a heart
That longs to be free.

Psalm 9: 10
And those who know your name put their trust in you,
for you, O Lord, have not forsaken those who seek you. ESV

Psalm 71:5
For Thou art my hope, O Lord God, thou art my trust from my youth.

Printed in the United States
by Baker & Taylor Publisher Services